DoGMA

A WAY of LIFE

A Bark & Smile™ Book

Kim Levin and Erica Salmon

**Andrews McMeel
Publishing**

Kansas City

02 03 04 05 06 TWP 10 9 8 7 6 5 4 3 2 1

ISBN: 0-7407-2707-9

Library of Congress Control Number: 2002103641

Book design by Holly Camerlinck

www.barkandsmile.com

Attention: Schools and Businesses

Andrews McMeel books are available at quantity discounts with bulk purchase for educational, business, or sales promotional use. For information, please write to: Special Sales Department, Andrews McMeel Publishing, 4520 Main Street, Kansas City, Missouri 64111.

For Neil (ES)

For Claire and Laurie (KL)

Acknowledgments

This book, and the experience of writing it, would not have been possible (or half as fun) without the generosity, talent, and foresight of Kim Levin. After we "met" each other through e-mail, Kim graciously agreed to look at a book idea I had called *Dogma*. After meeting each other in person, we knew we shared a similar work ethic, a sense of humor, and perhaps most important, a belief that we can all learn a thing or two from the way dogs live. I would like to thank Kim for working with me and for being so thorough and professional in how she approached each page of this book. I have learned a great deal over the past two years and have gained a good friend in the process. Thank you, Kim.

Erica Salmon

Thank you to all of the dogs (and their owners) who appear in *Dogma*. This book would not be possible without you. We would like to thank Dorothy O'Brien and the wonderful team at Andrews McMeel Publishing. We'd also like to thank Jim Hutchison for his talent and all of his hard work developing the quality prints in *Dogma*. Our husbands, John O'Neill and Neil Salmon, have been supportive and have offered invaluable advice along the way. Our dogs, Charlie, Peaches, and Annabelle, have inspired us and continue to keep us humble.

We hope you enjoy reading this book as much as we have enjoyed creating it!

ES and KL

dogma (dôg'mə)

n. 1. A principle, belief, or statement of an idea or opinion. 2. A system of beliefs or ideas. 3. A way of life.

Wonder, ponder, and reflect.

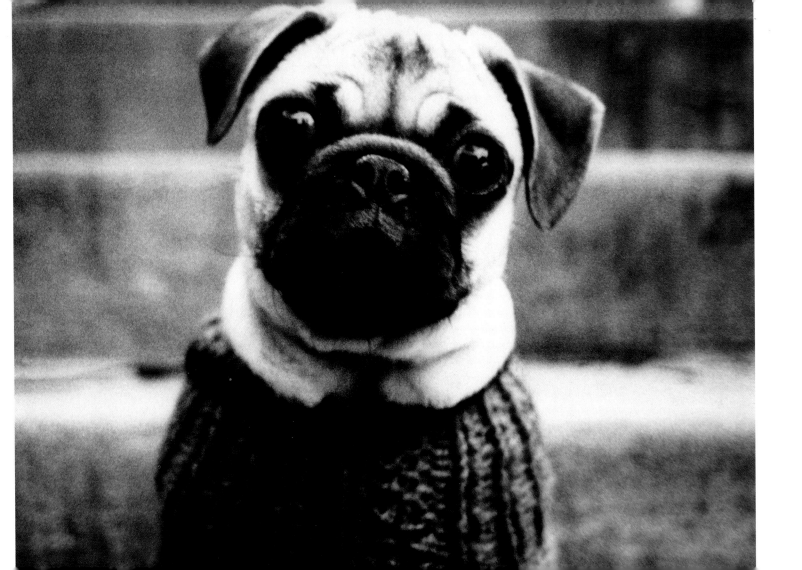

Wait for those *love*.

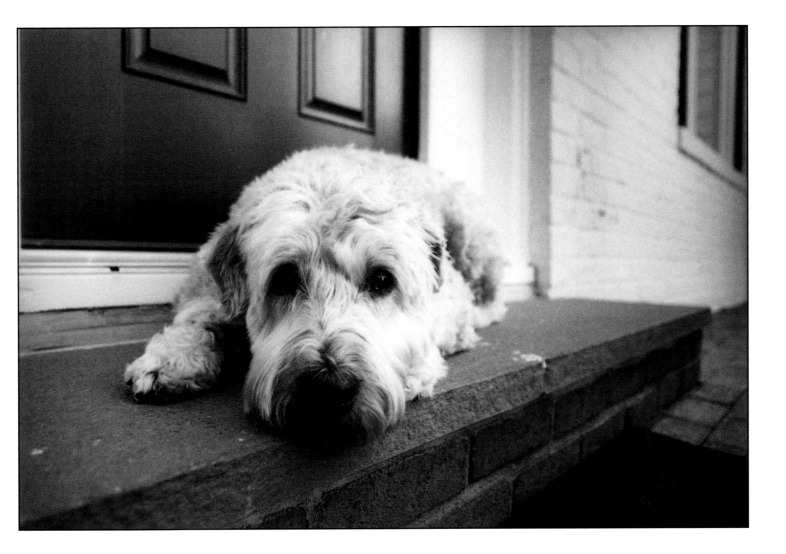

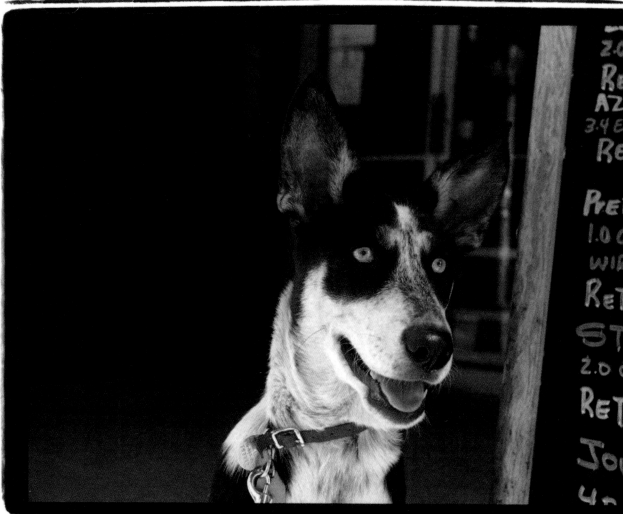

Listen with all ears.

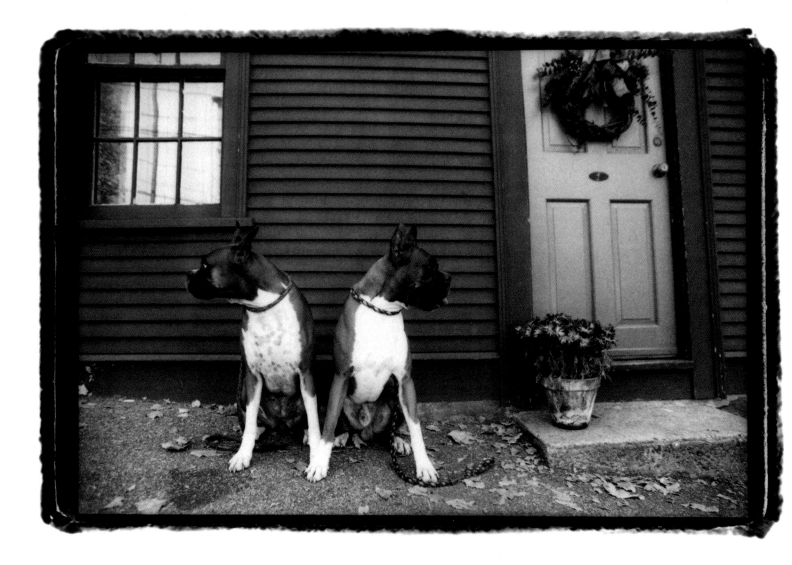

Watch each
other's back.

Don't feel guilty for sleeping in.

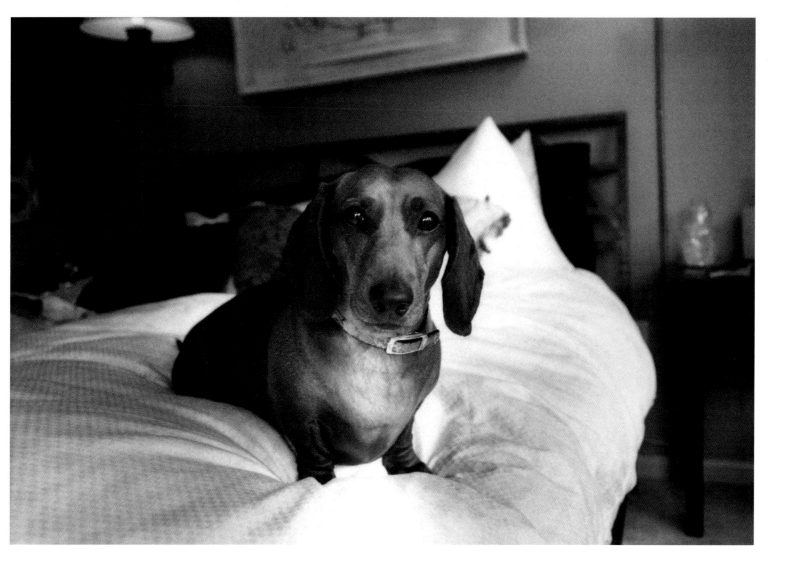

Admit when you're wrong.

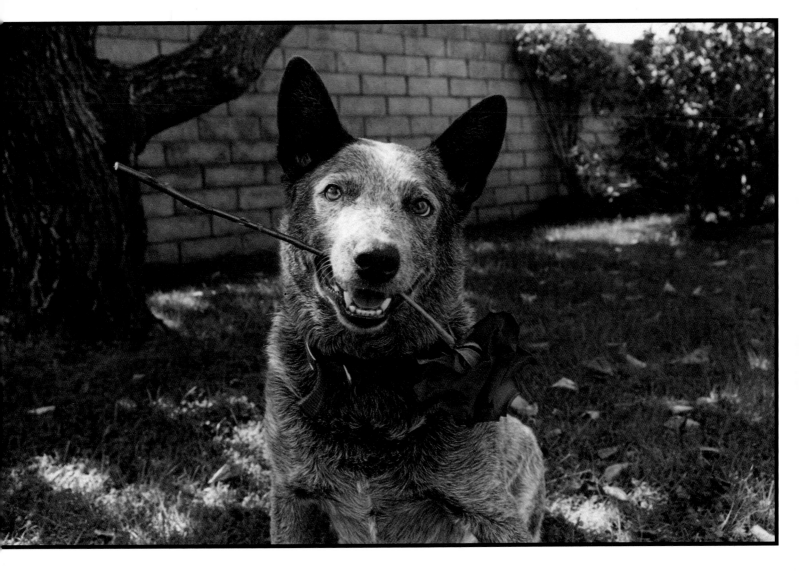

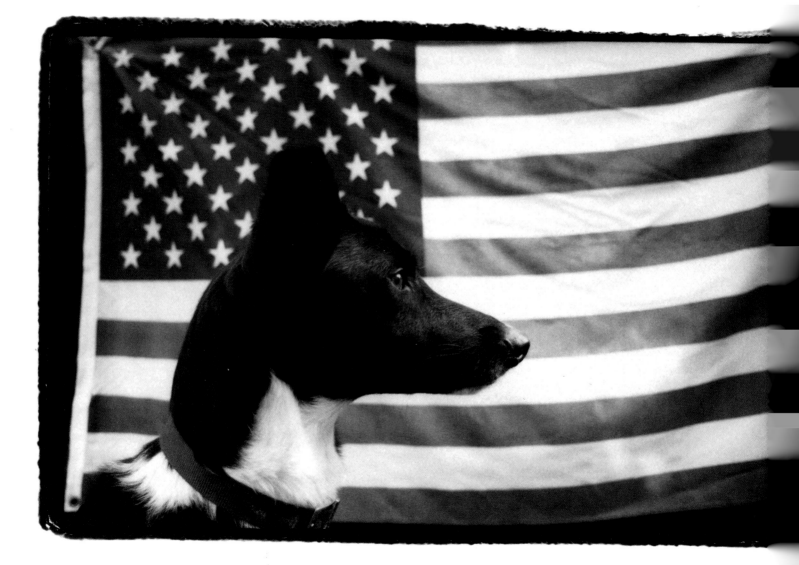

Be proud.

Befriend all sorts of creatures.

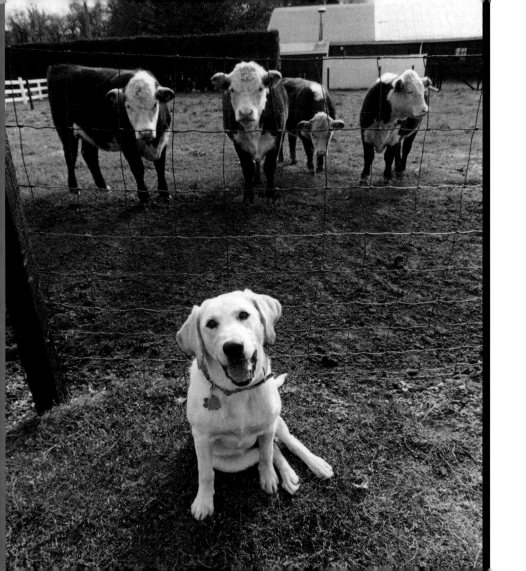

Take responsibility for your actions.

Be humble.

Give gentle kisses.

Go skinny-dipping

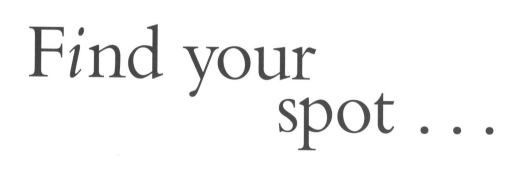

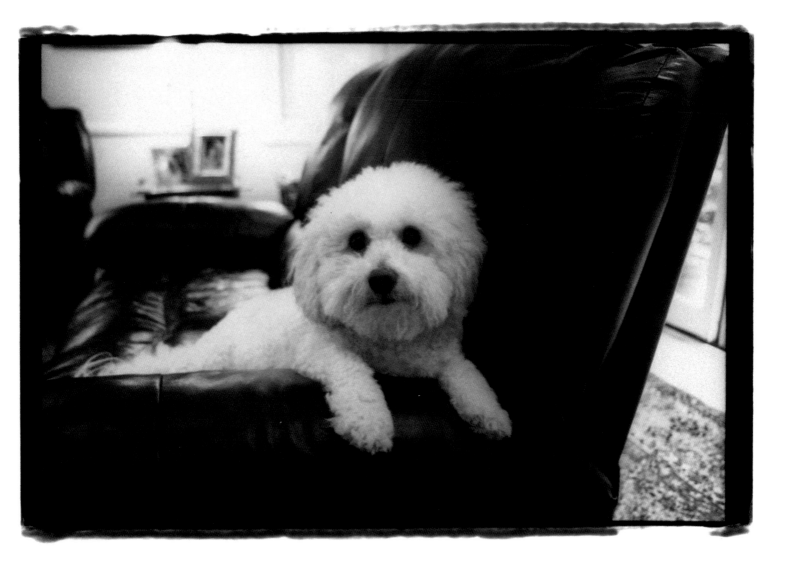

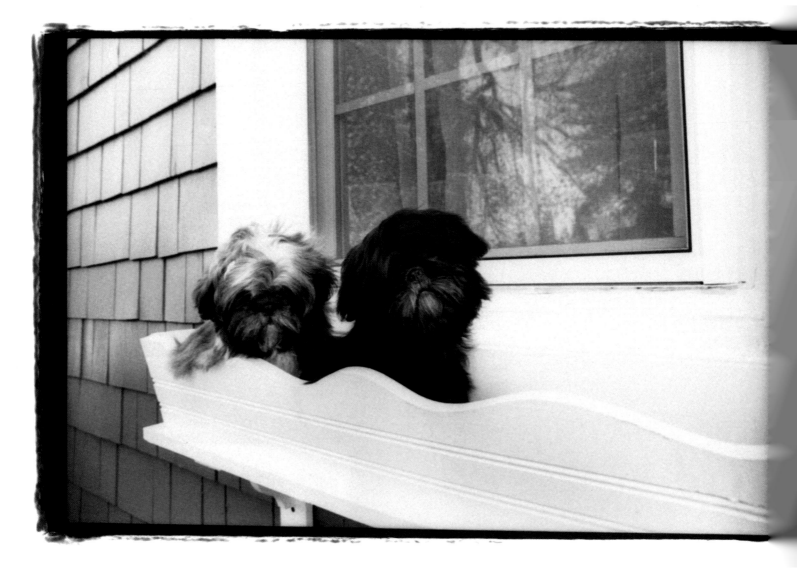

and spend t*i*me
there.

Smile,
even if your teeth aren't perfect.

Be pleasant.

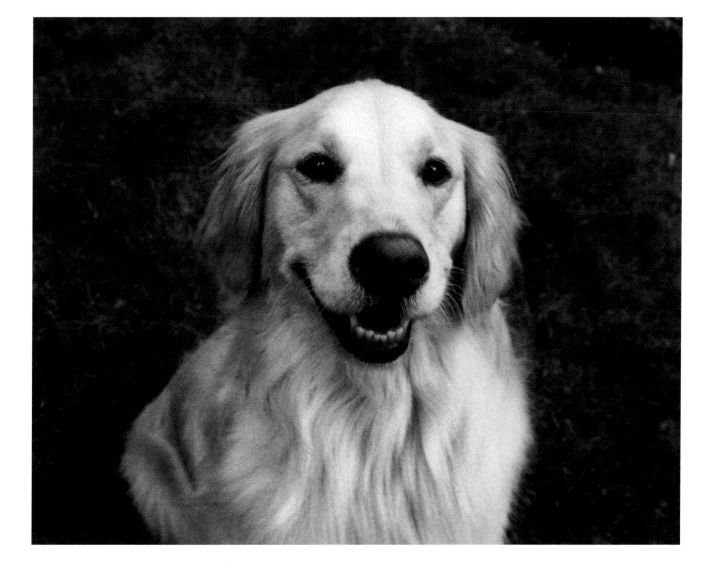

Drink plenty of water.

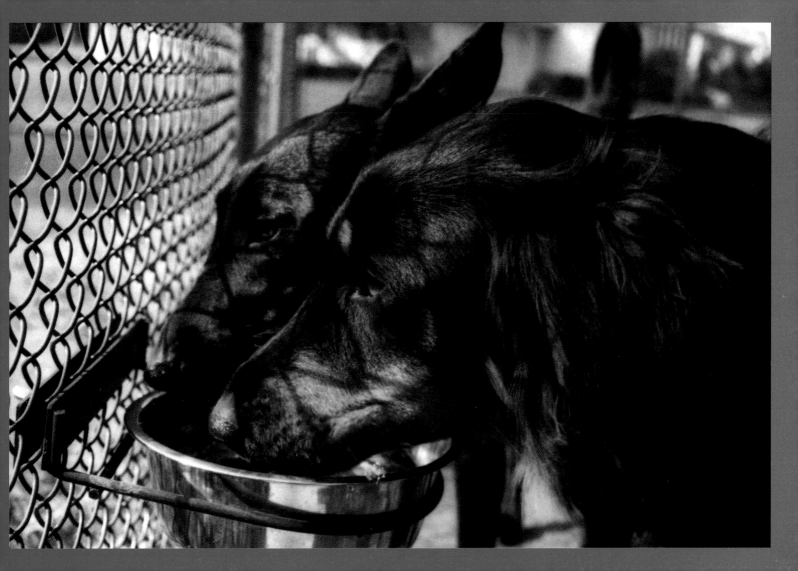

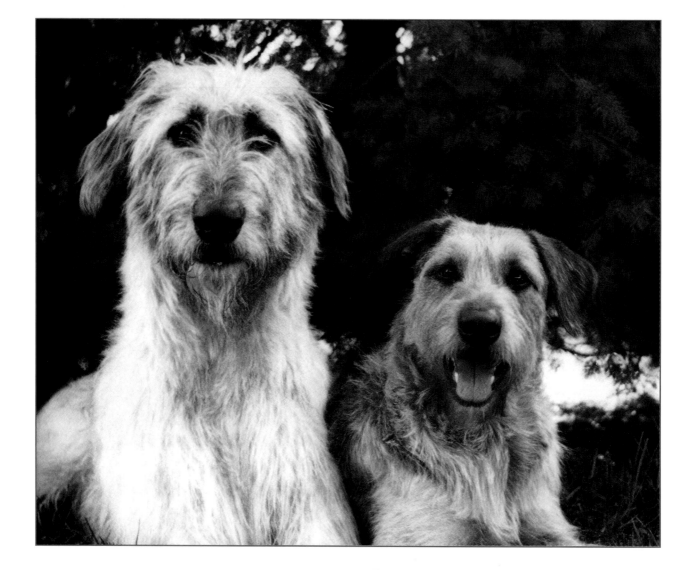

Find a companion.

Practice
 patience.

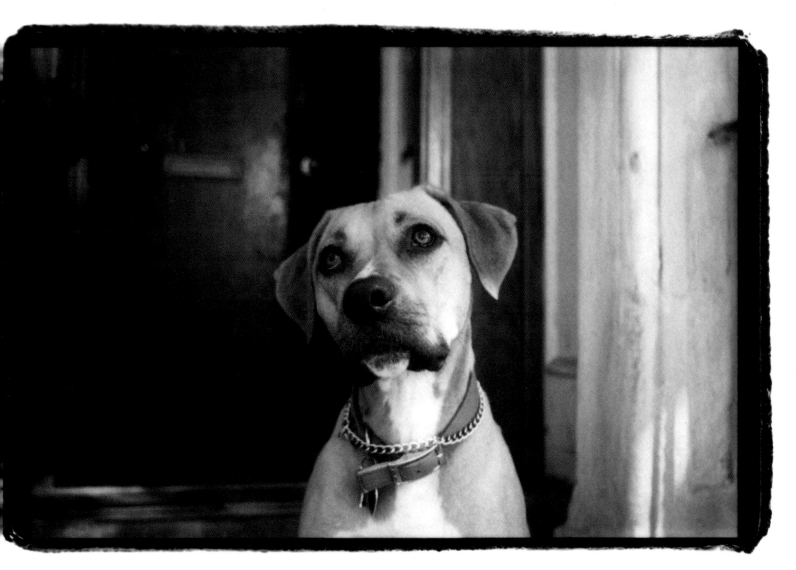

Show how you're feeling...

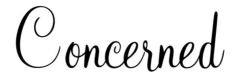

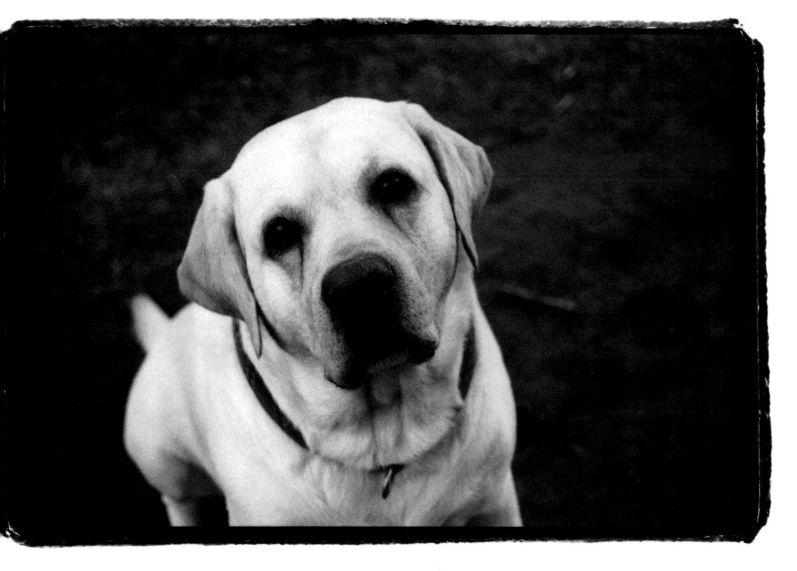

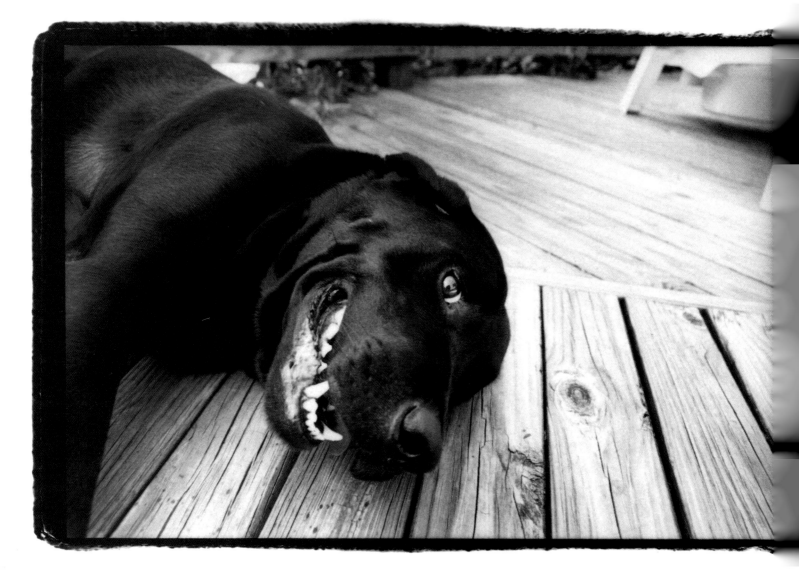

Silly

Confused

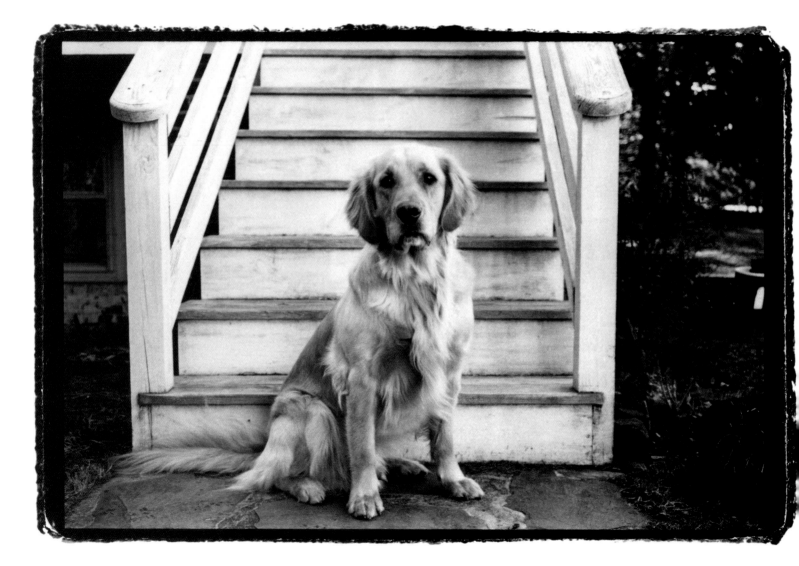

Confident

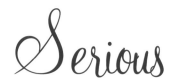

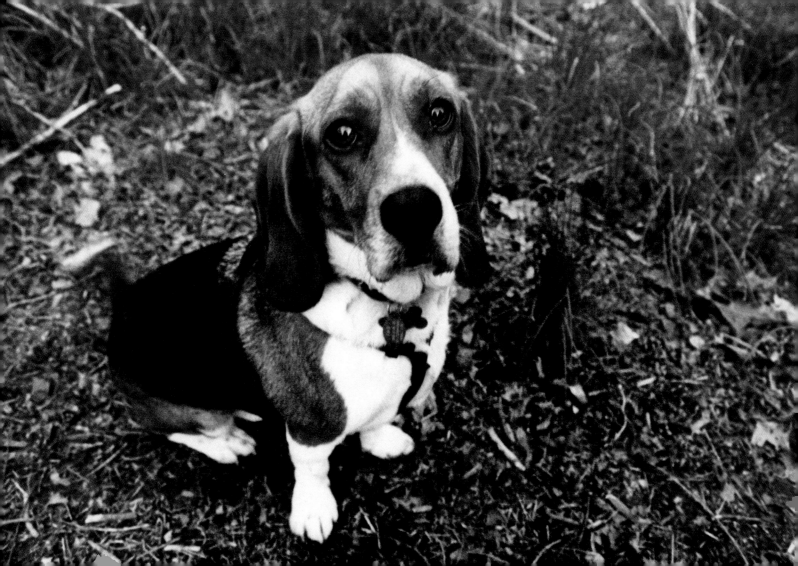

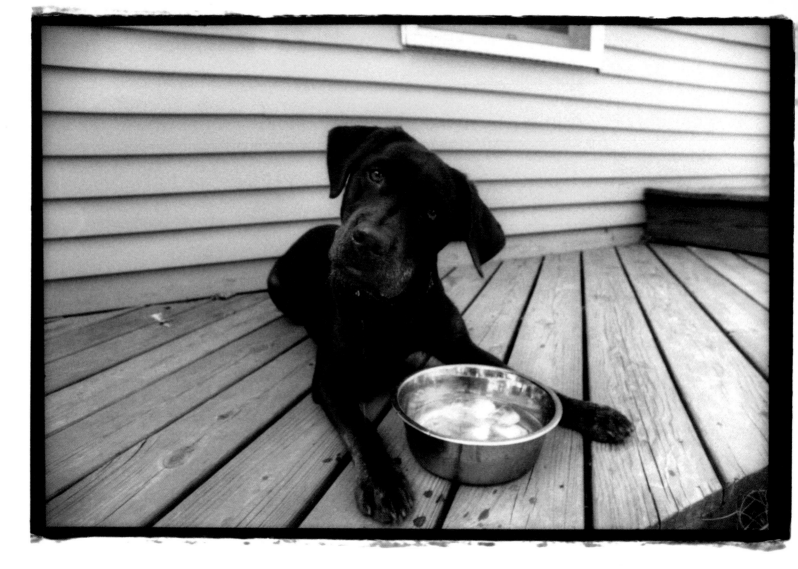

Happy

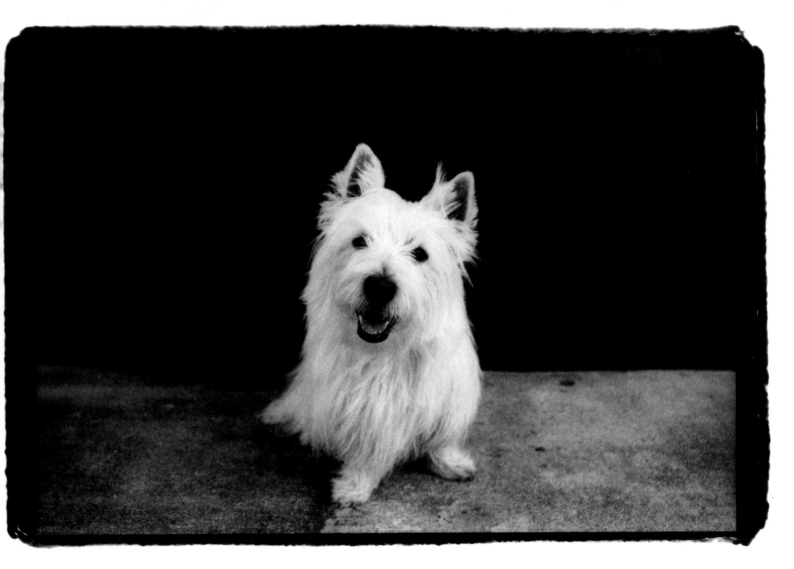

Explore your own backyard.

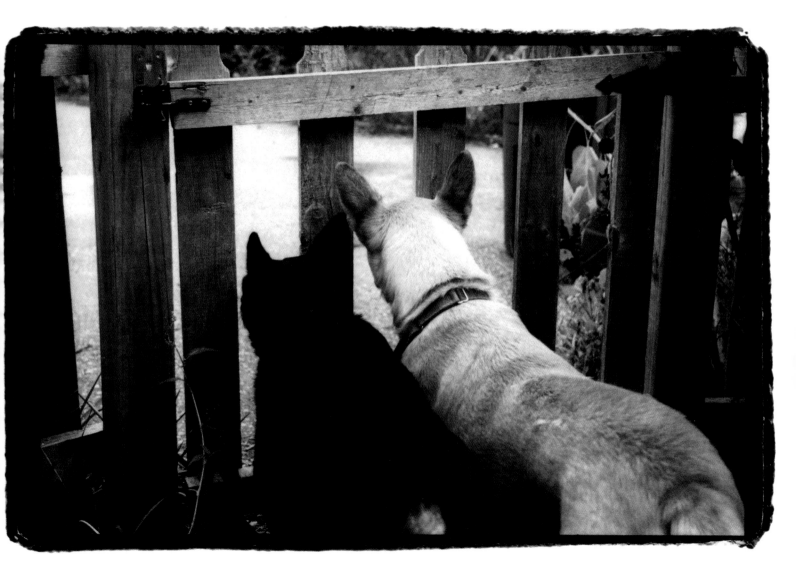

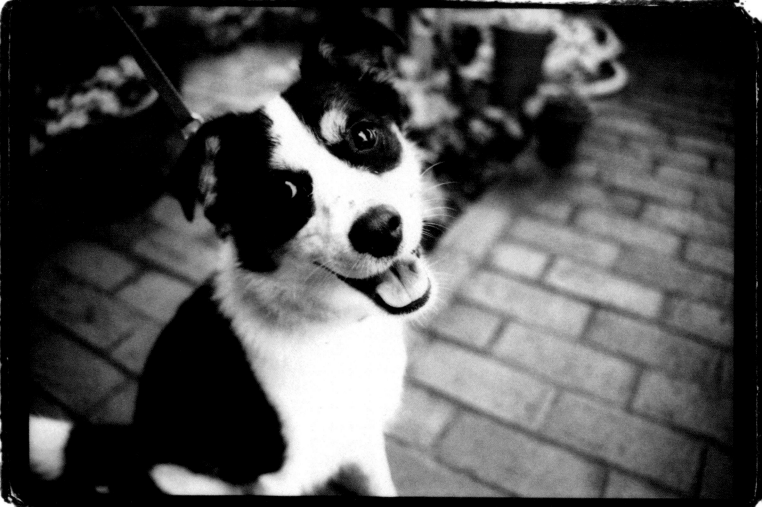

Greet strangers.

Let loved ones call you silly names

like "Stinky" and "Sweet Pea."

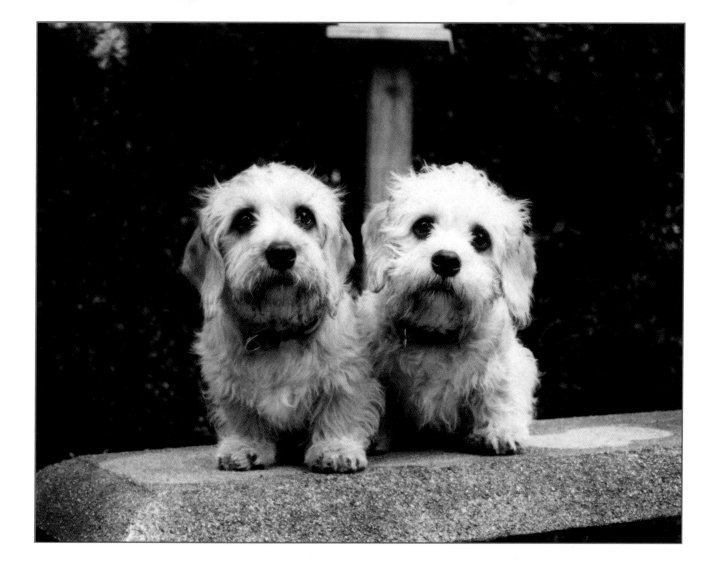

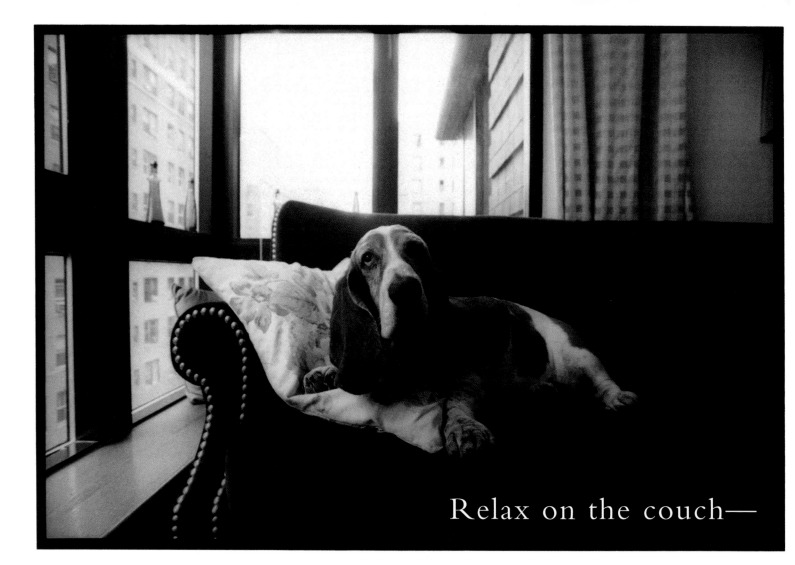

Relax on the couch—

it's often therapy enough.

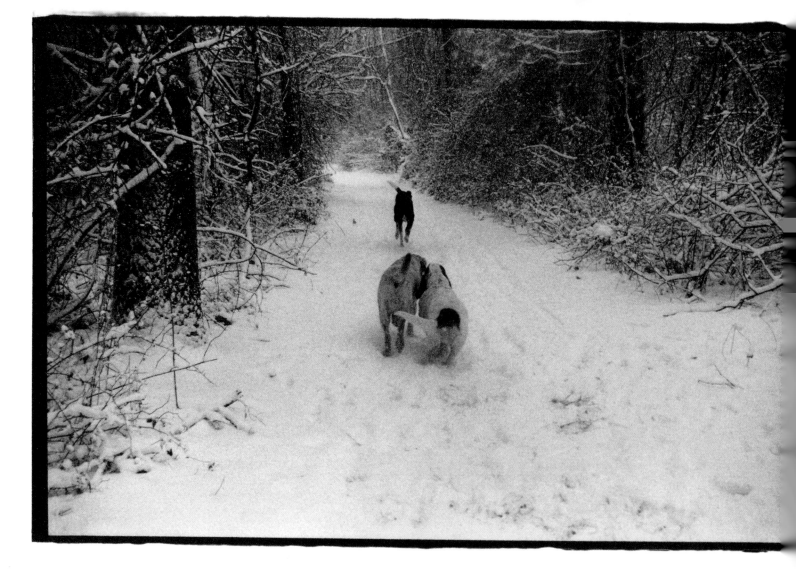

Take
long
walks . . .

and
long
runs.

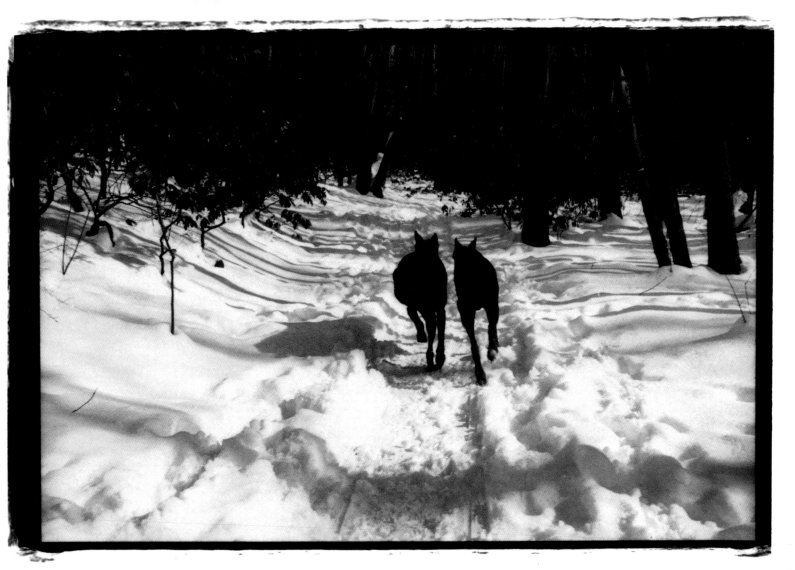

Accept that bad hair days happen.

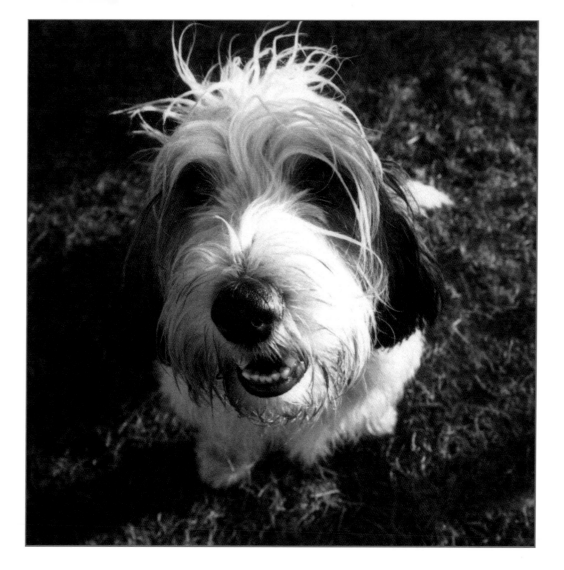

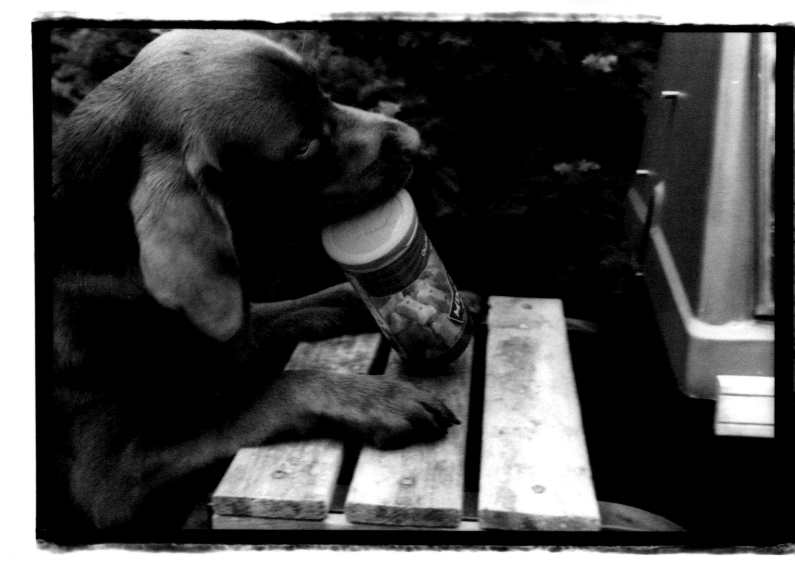

Help yourself to treats.

Protect the ones you love.

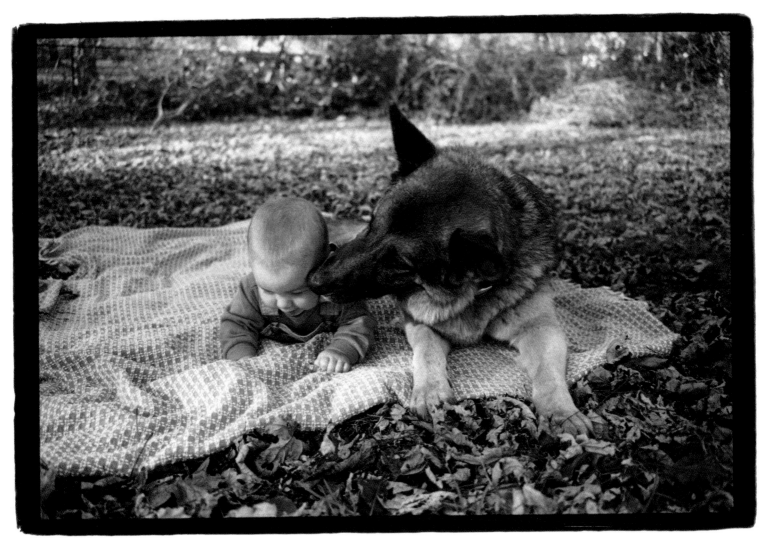

Know your boundaries.

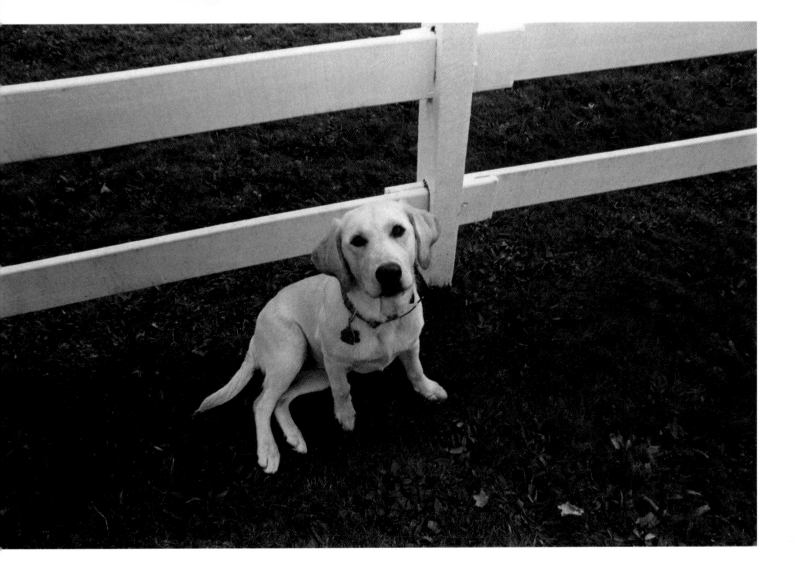

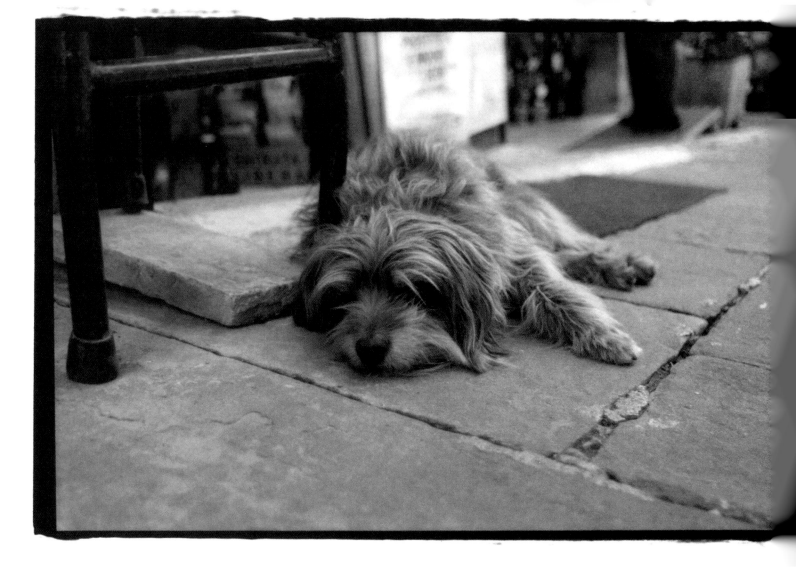

Nap often.

Don't let
your name
hold you back.

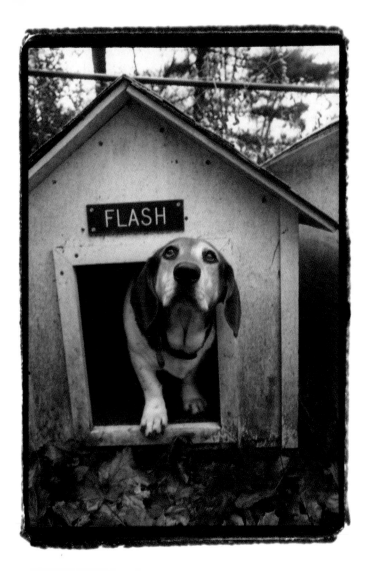

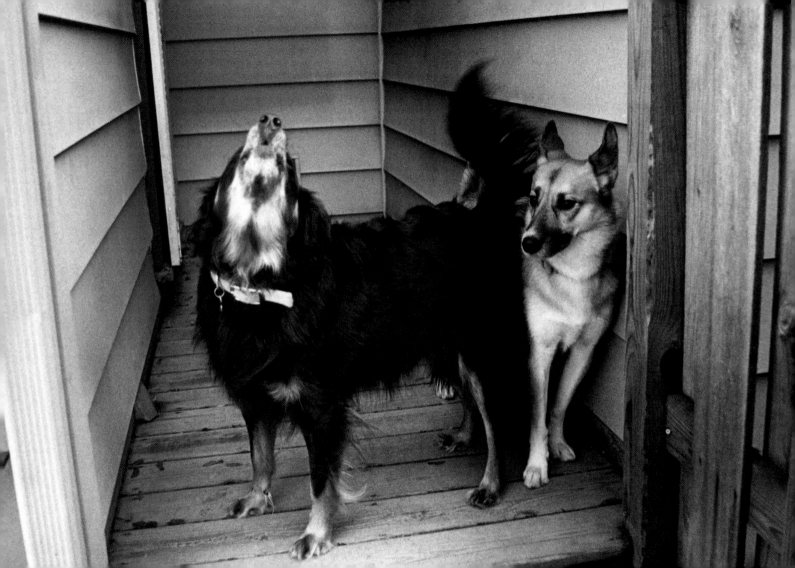

Sing,

even if you sing off-key.

Exercise when the spirit moves you.

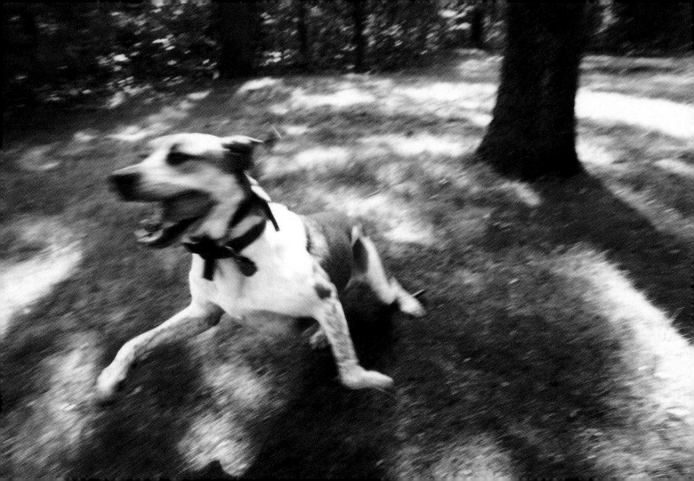

Lounge.

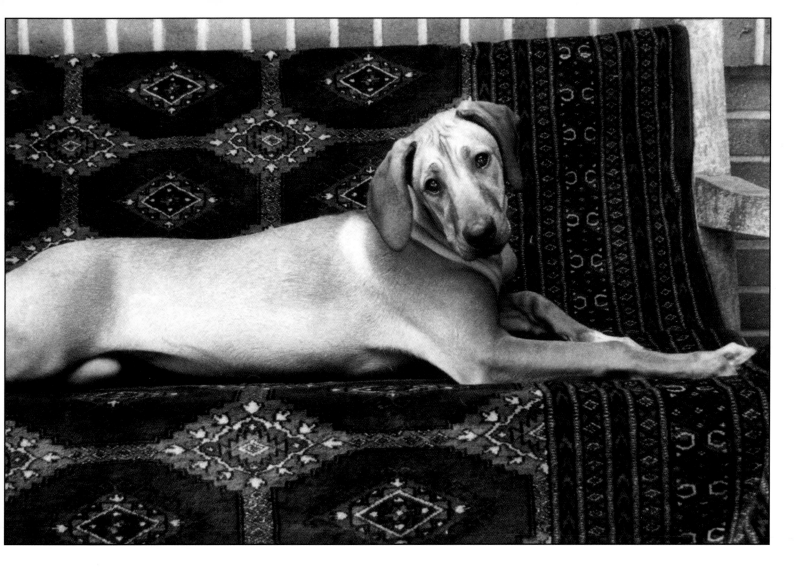

Soak in the warmth of the sun.

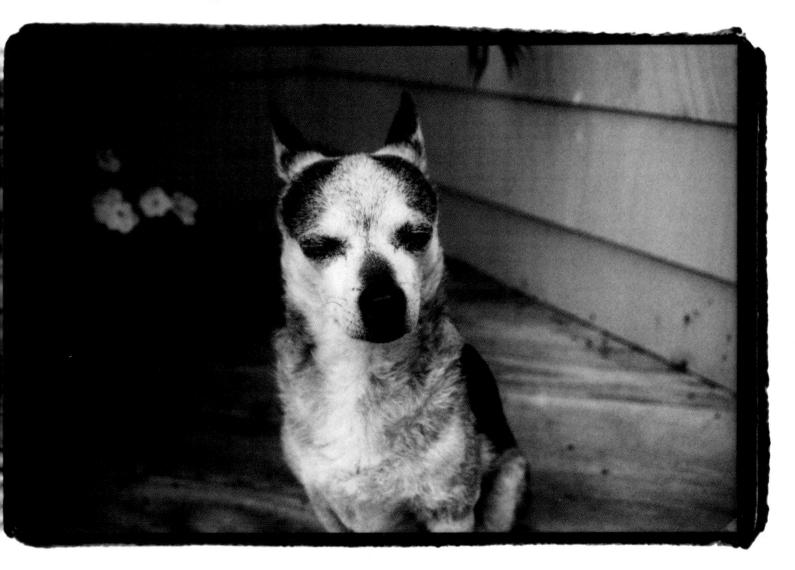

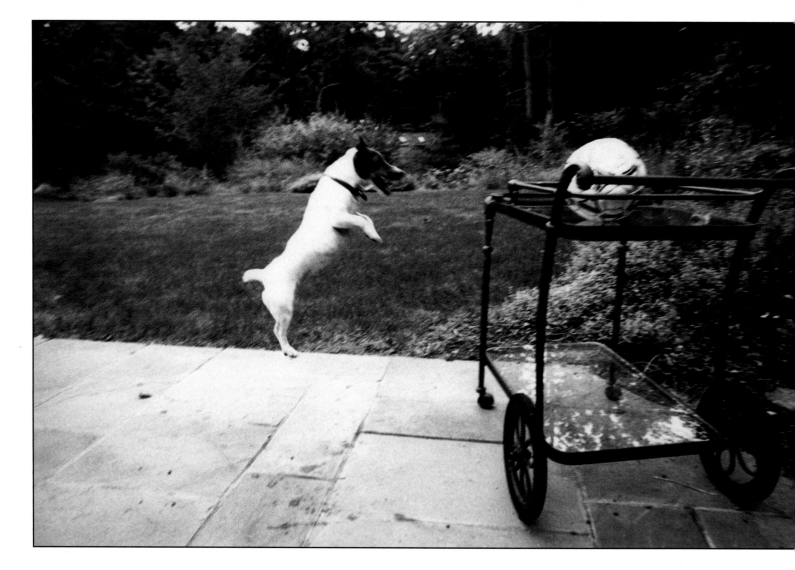

Keep your **eye** on the ball.

Stay innocent.

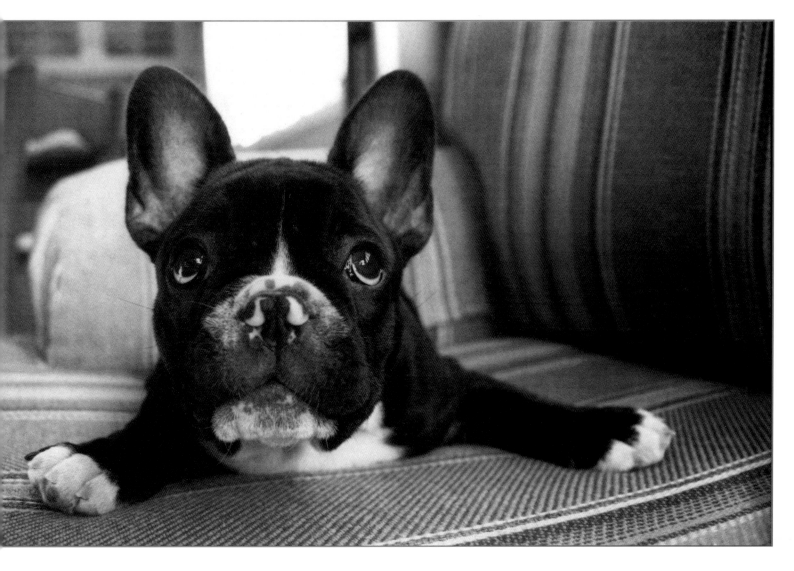

Be endearing.

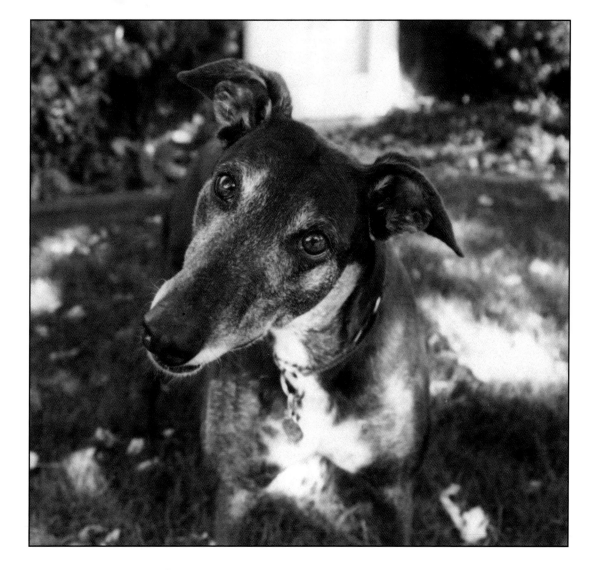

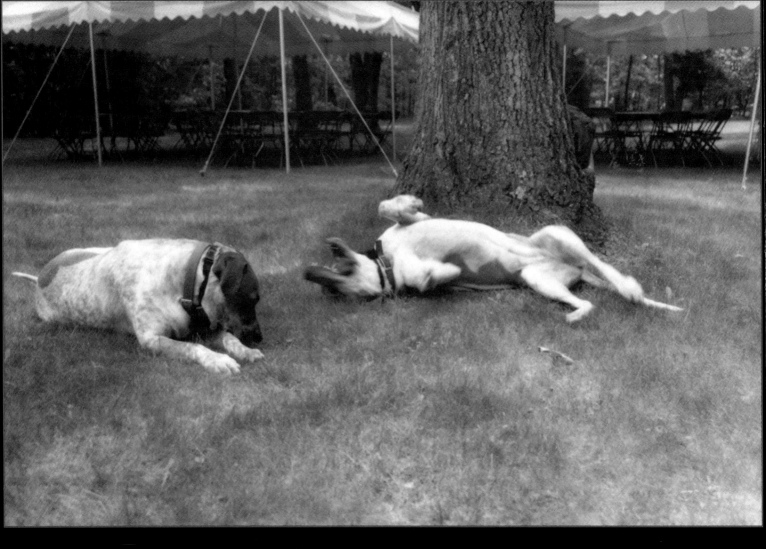

Tell good, clean jokes.

Forgive 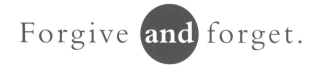 and forget.

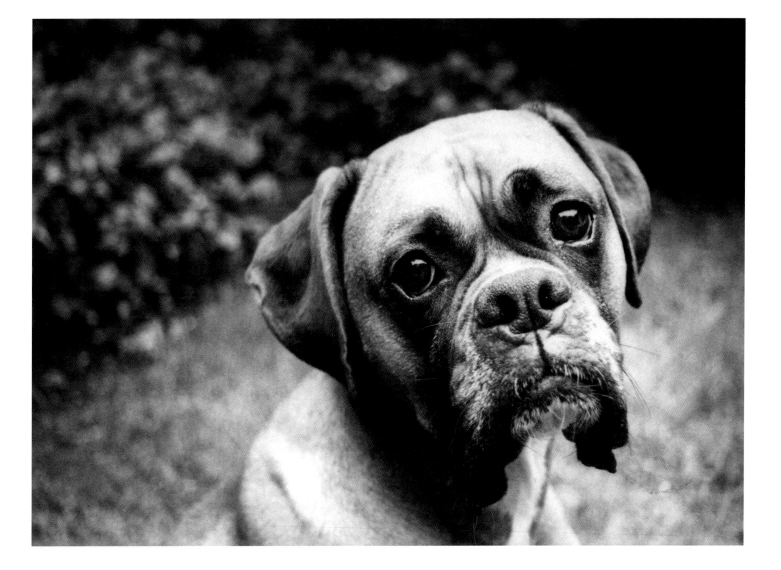

Follow your own path.

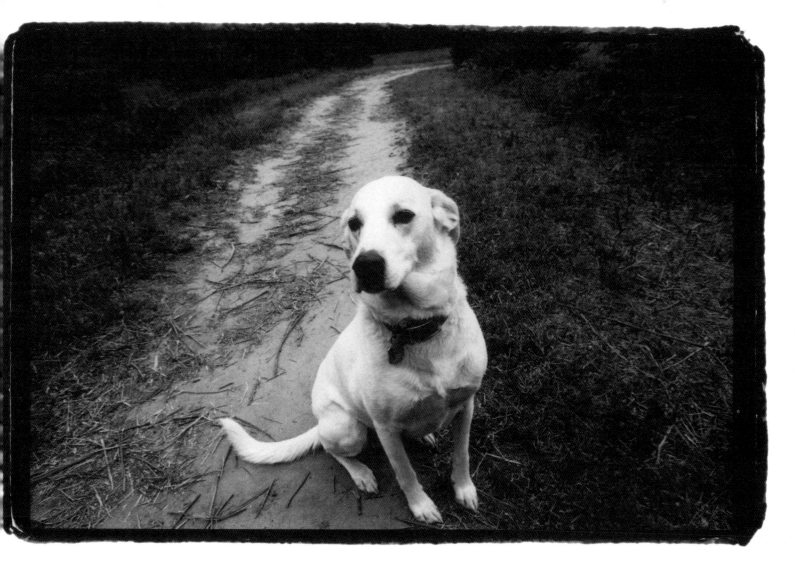

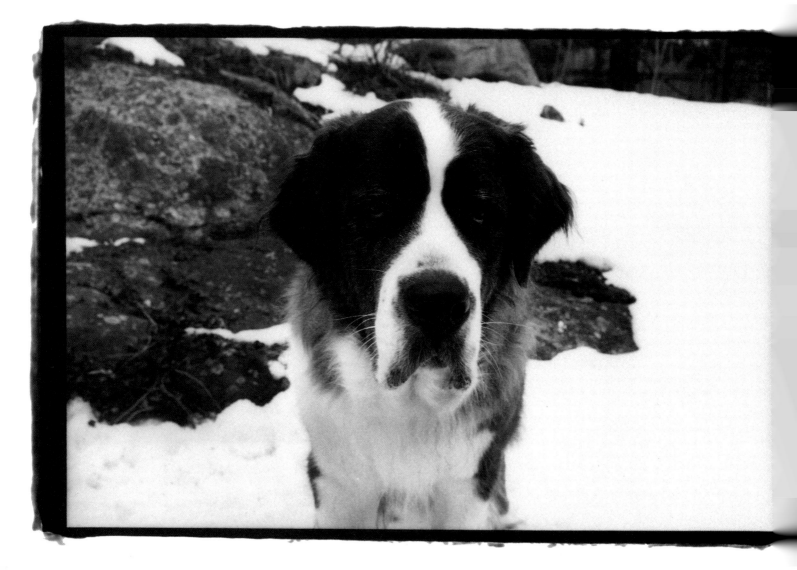

Live where it suits you.

Accept gifts graciously.

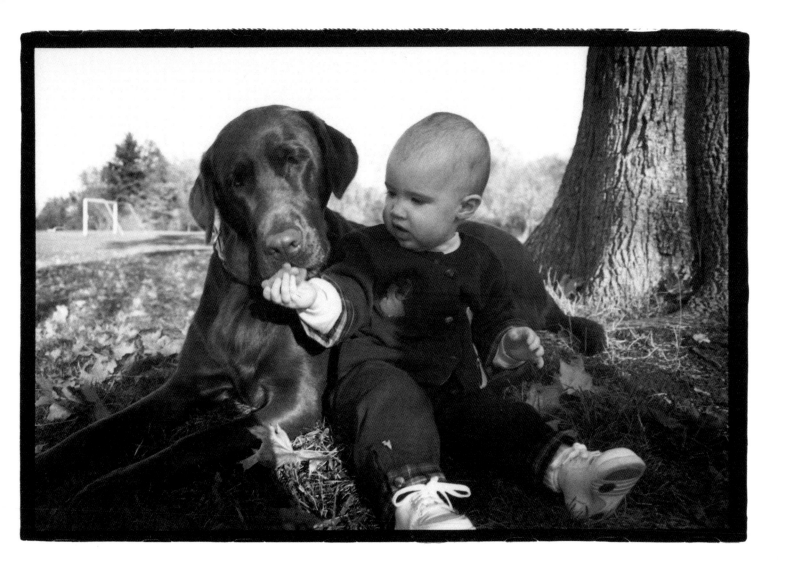

If your car has four wheels and a window,
don't worry about what kind it is.

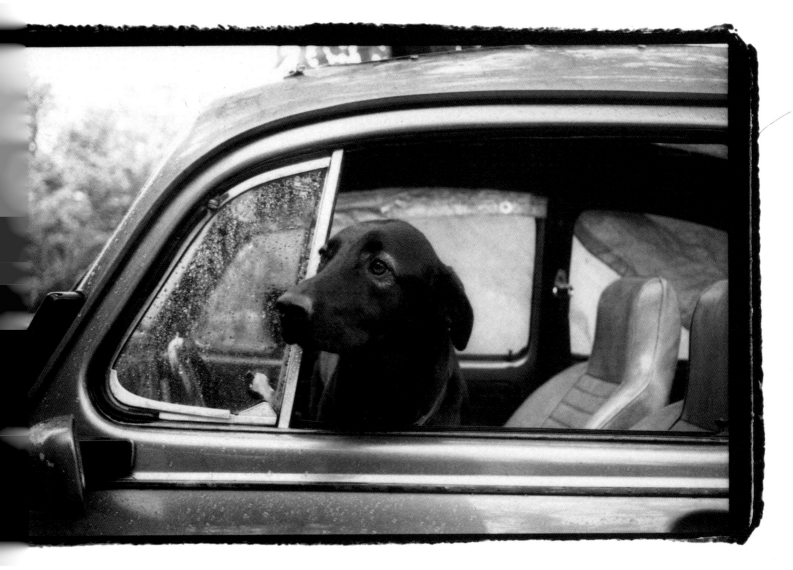

Be sensitive.

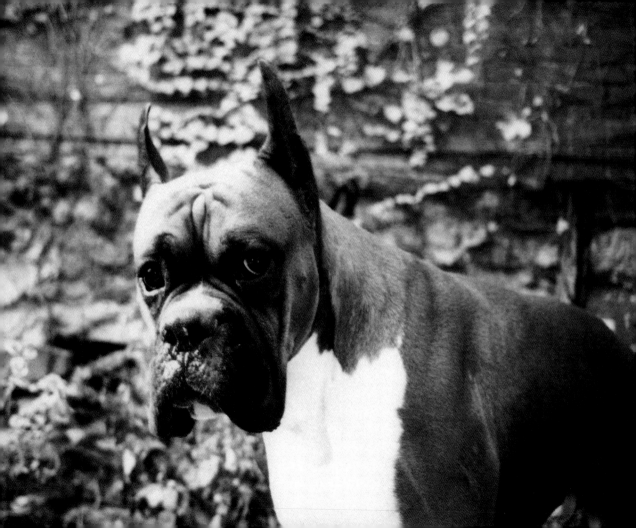

Keep secrets.

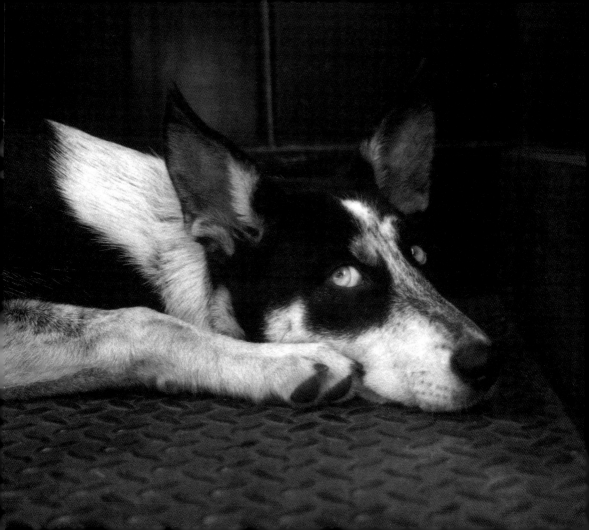

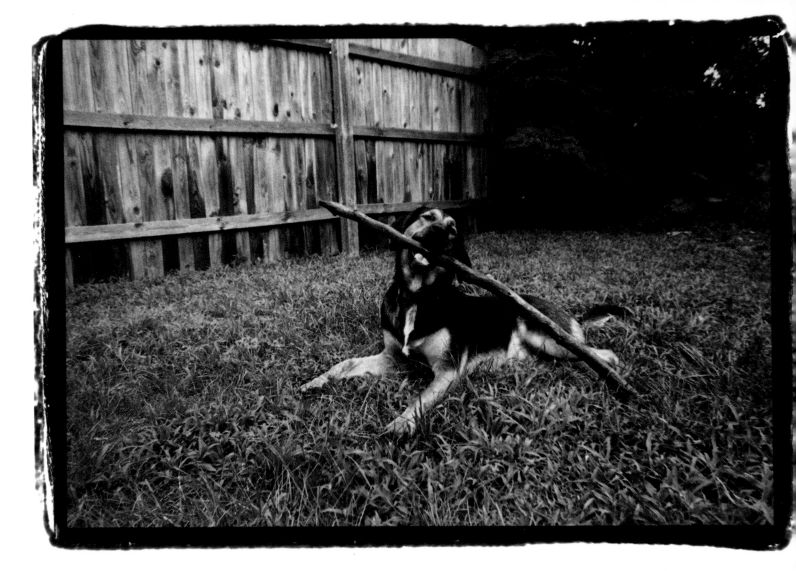

Think
big.

Smile **for the camera.**

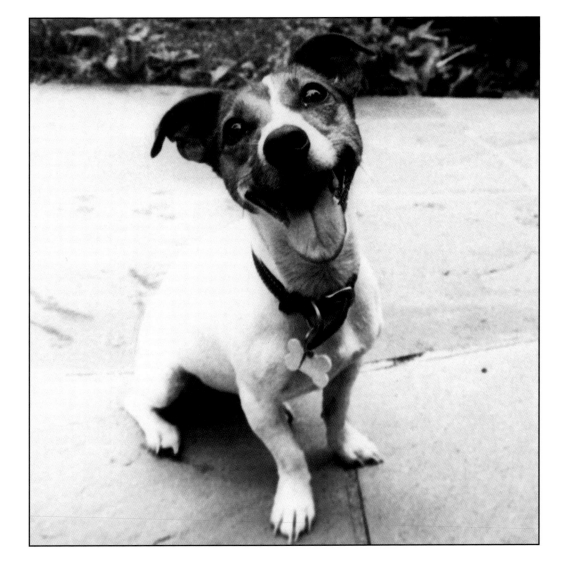

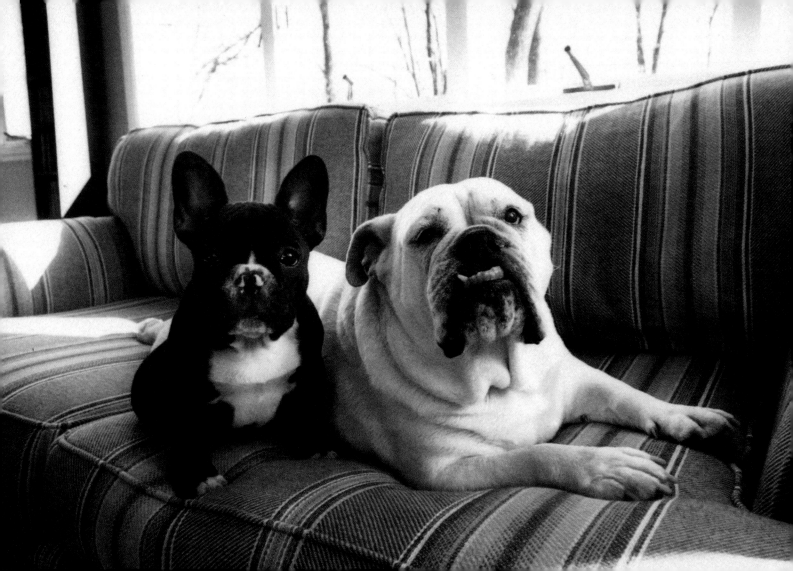

Make room for new additions.

Look
at things
from a
new
angle.

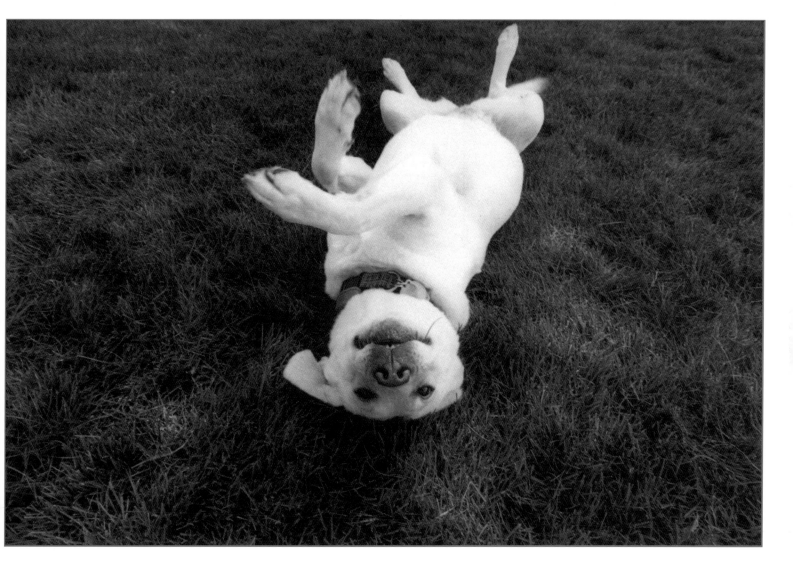

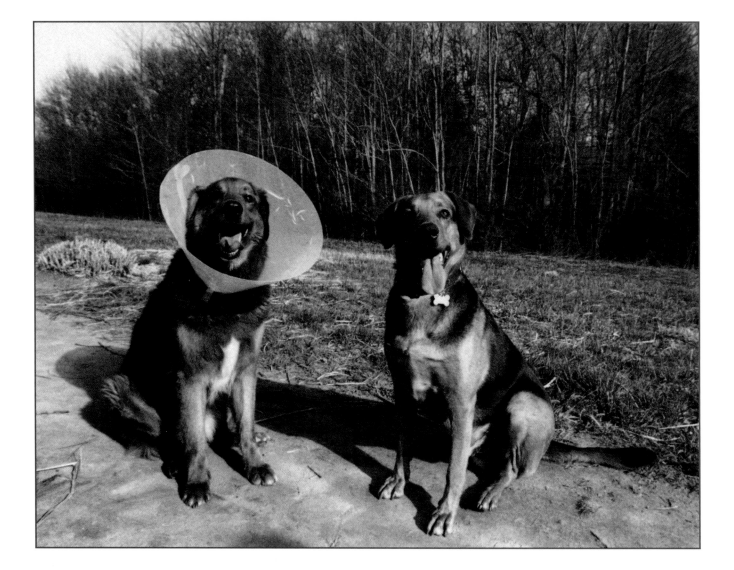

Spend time with friends
 when they're not feeling their best.

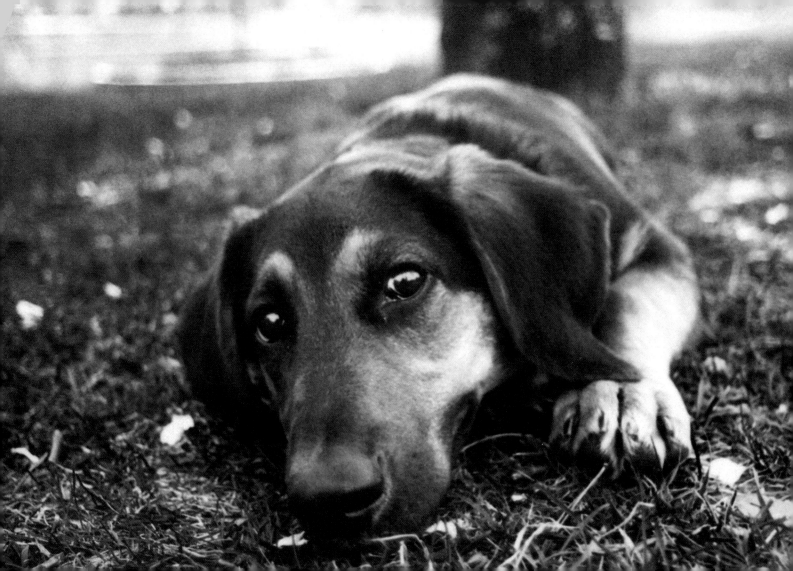

Look at those you love with
"puppy dog eyes."

Don't be a
party pooper.

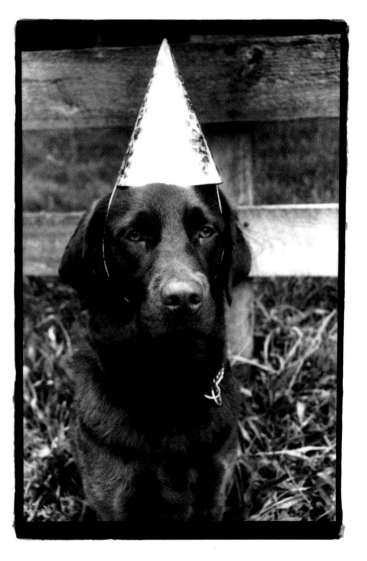

Believe that you can do anything.

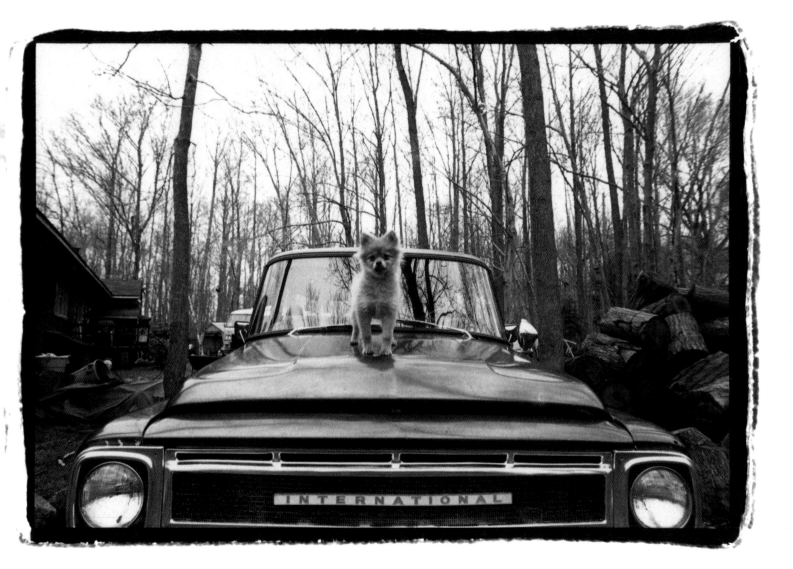

Spend a night on the town!

Think before you speak.

Grow old gracefully.

Be yourself,
as goofy as that may be.

Show 'em
how you
really feel.

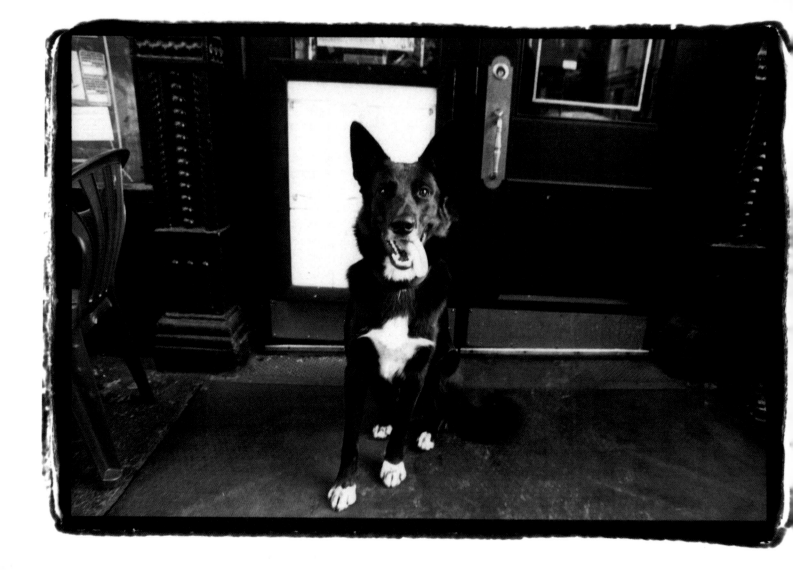

Live each year of your life like it's worth seven.

Shout out
when you
sense trouble.

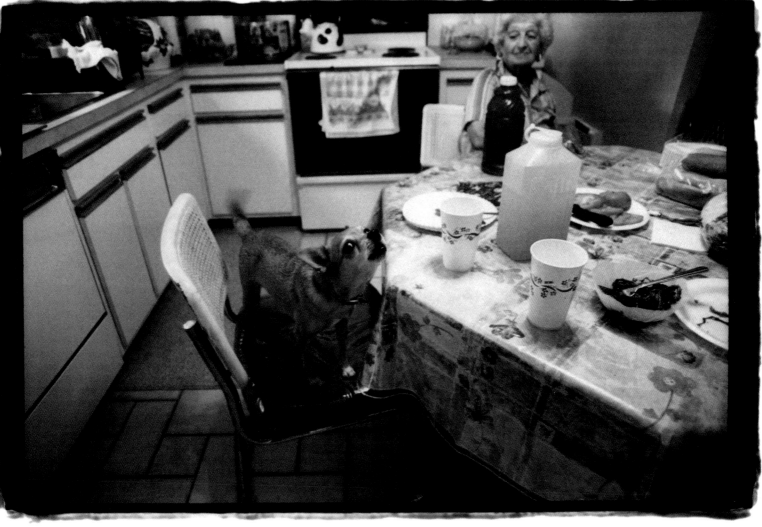

Take time to smell
 the roses, tulips, dandelions,
 and every blade of grass in between.

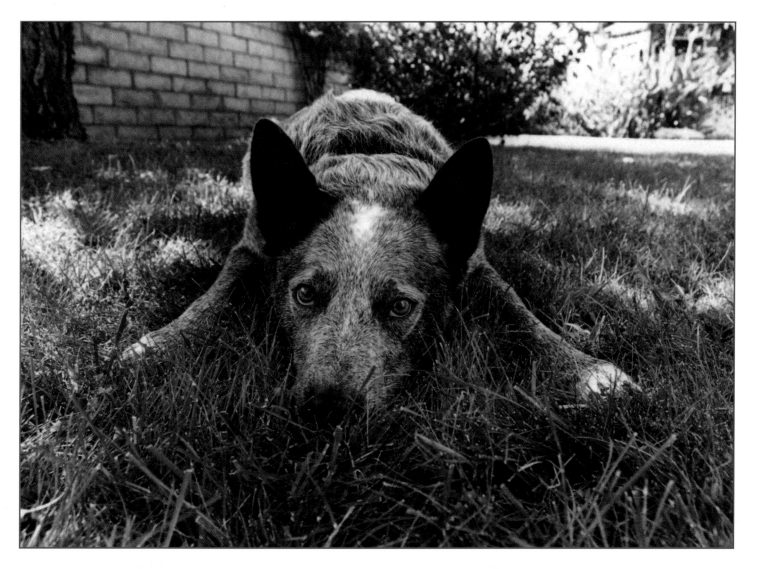

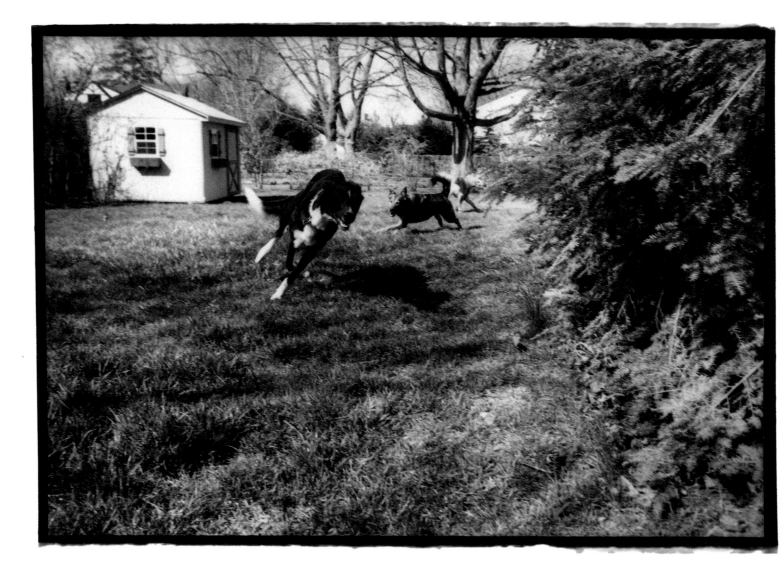

Play hard.

Relax even harder.

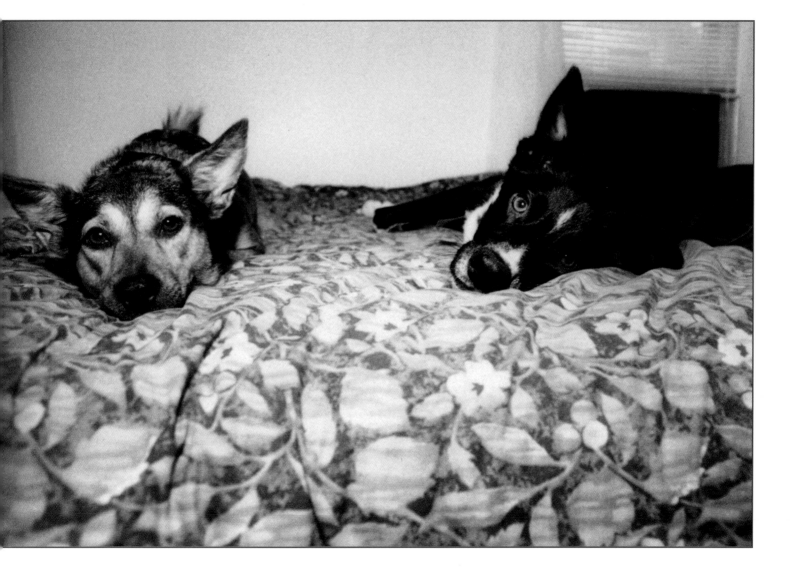

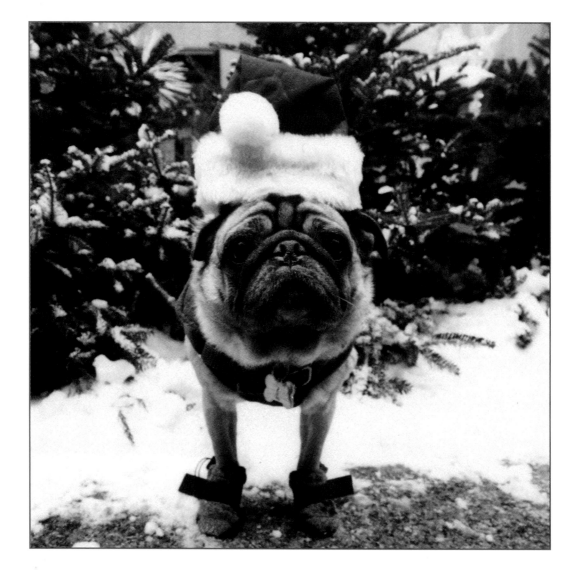

Be merry.

Make time for friends.

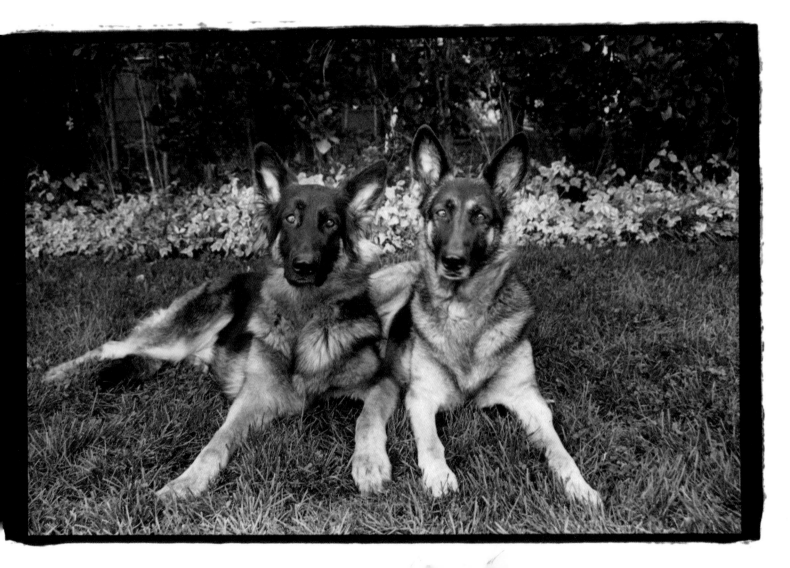

Understand that beauty
is in the eye of the beholder.

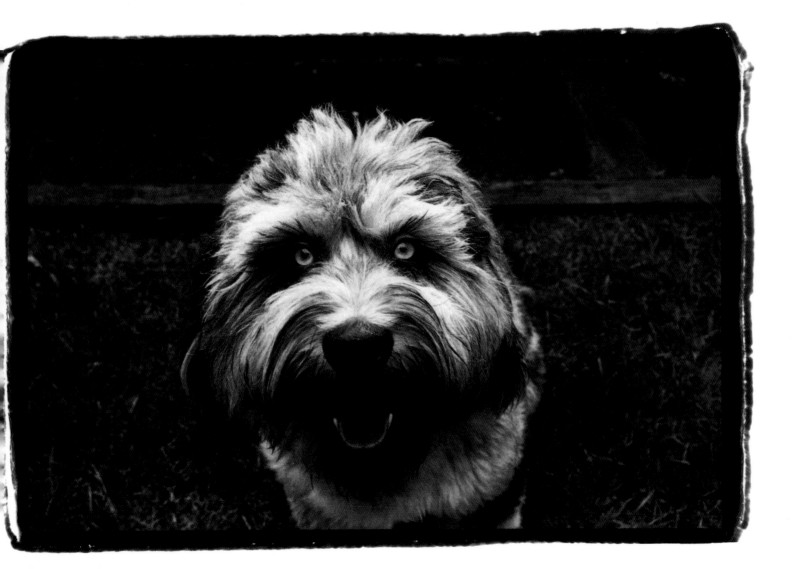

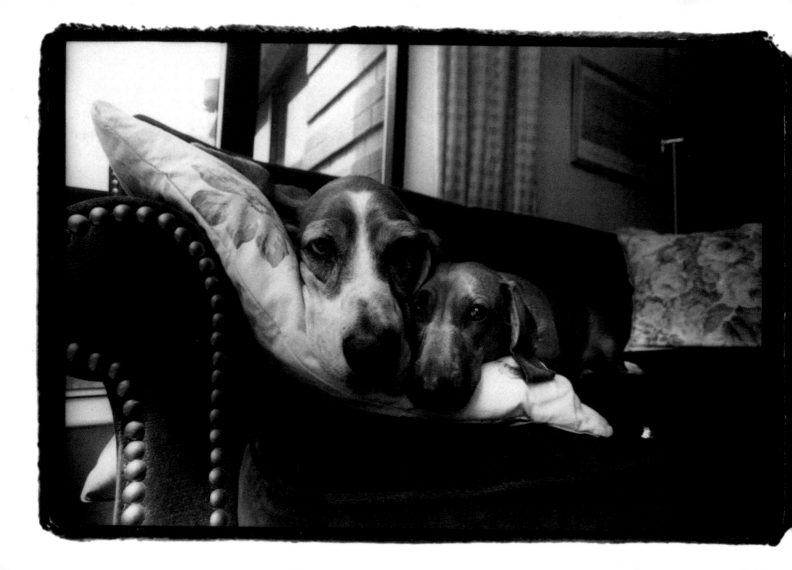

Love one another.

Other Books by Kim Levin

Why We Love Cats

Why We Love Dogs

Why We Really Love Dogs

Dogs Are Funny

Dogs Love . . .

Erin Go Bark! (with John O'Neill)

For the Love You Give (with John O'Neill)

Working Dogs: Tales from Animal Planet's K-9 to 5 World